100 THINGS

TO DRAW WITH A

CIRCLE

Start with a shape;
doodle what you see.

SARAH WALSH

QUARRY

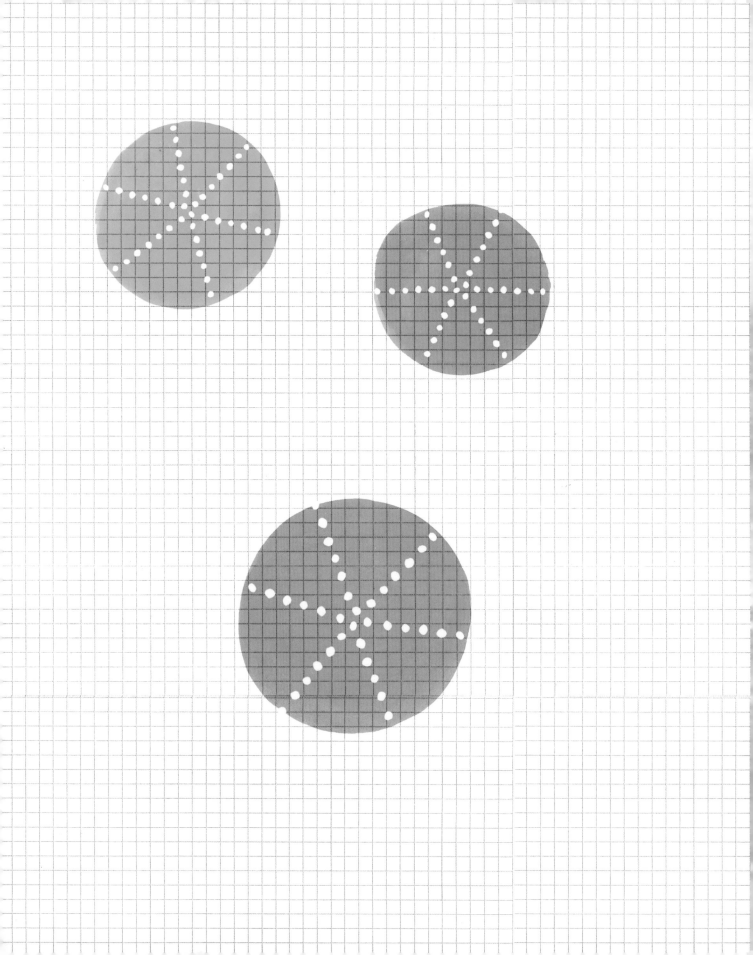

INTRODUCTION

A simple shape can suggest many things. Perhaps none more so than the circle. Think of it, it's everywhere—on the face of a wristwatch and stacked in kitchen cupboards, in every sunset and moonrise, in gears and wheels and wedding rings and sitting on bakery shelves. The circle has always been at the core of art, inspiring designers and engineers. Now it's ready for doodlers, too.

In this book, one or many circles appear on every page. They might be outlines or solids, scattered or overlapping, brightly colored or black and white. Look at them and what do you see? A solar system or a grapefruit? A game of checkers or a drop of rain in a puddle?

Now pick up a pencil, pen, or paint brush and fill in the parts that aren't already there. A circle is meaningless until you decide what it wants to be. A companion to *100 Things to Draw with a Triangle*, this is a book for loosening the imagination, playing with ideas, and for inspiring creative thought. The simplest of shapes brings you back to the basics and lets you create anything you can see in your imagination.

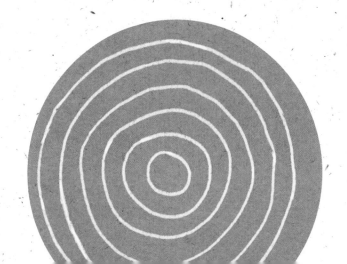

HOW TO DOODLE THIS BOOK

A circle is just a
circle until you decide
what it wants to be.

So pick up your pencil and doodle what you see.

Is it a fancy flounce?

See more

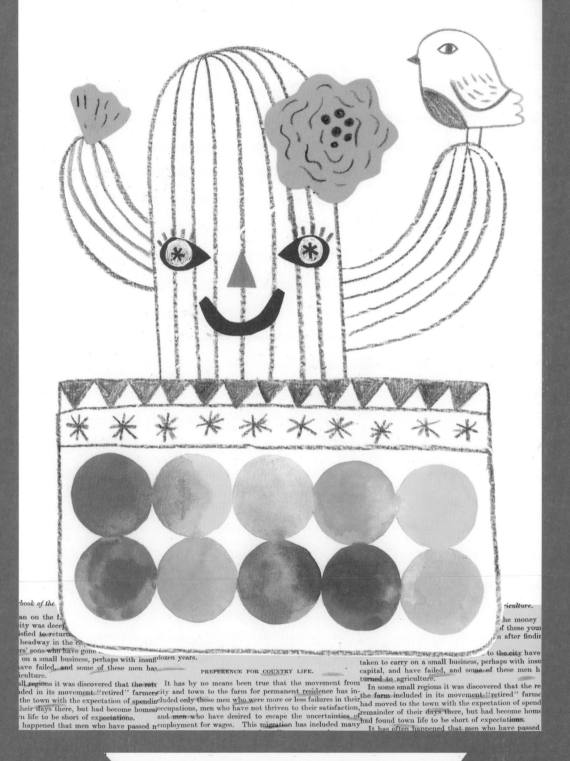

Is it a cactus planter?

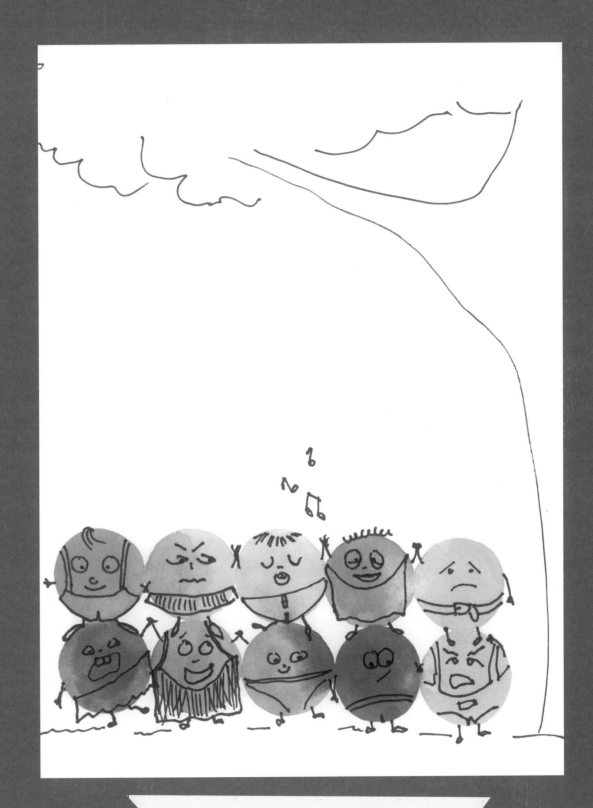

Is it a bunch of oddballs

HOW TO DOODLE THIS BOOK

What do you see? Draw what you see.

Is it a showy shell?

Is it a new set of wheels?

Is it a pair of posies?

Is it a bug's eye view

HOW TO DOODLE THIS BOOK

What do you see? Draw what you see.

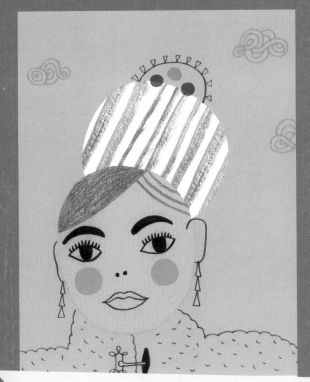

Is it a chic chapeau?

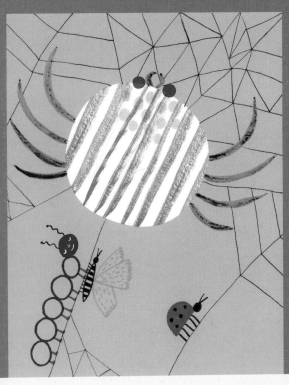

Is it Miss Spidey's new stripes?

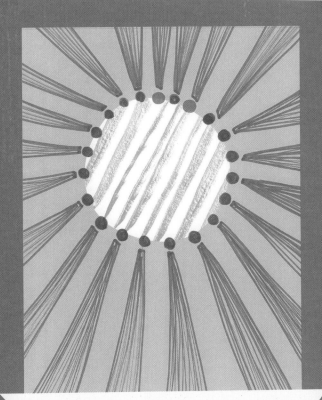

Is it the center of attention?

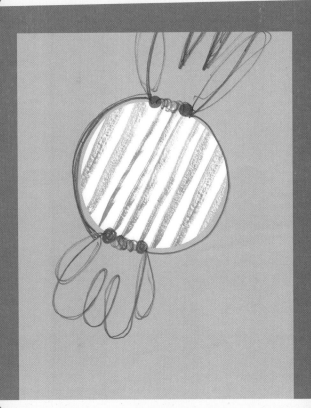

Is it a lone peppermint?

...tative Kunstform ist, bezeichn...
...er als „heiligen Raum"; andere würden es vi...
...n. Mit Zentangle entstehen nicht nur schöne Kuns...mp...
...dernen Lebens etwas entgegenzusetzen. Studien beleg...en – wie...
...stige Fitness steigert, zu Kreativität anregt, die Stimmun...im Schaffen...
...eruhigen und der Aggressionsbewältigung dienen kann. M...wie die Augen...
...Inhalten auseinandersetzen, helfen die Zentangle-Übungen, ...an kann von Zen...
...e wenn man nach einem Mittagsschlaf erfrischt aufwacht. Durc...n Tag. Zudem mus...
...naffen von Mustern und Designs selbstbewusster und schult freih...usstattung, Platz ode...
...die Augen-Hand-Koordination, die man für das Zeichnen braucht...as für Rick und Mar...
...kann von Zentangle also in vielerlei Weise profitieren und benötigt ...s „Tunnelblick", Yoga...
...ag. Zudem muss man nicht zeichnen können, denn Zentangle bring...onzentration" nennen...
...stattung, Platz oder handwerkliche Fähigkeiten sind auch nicht nötig...r Hektik des moderne...
...genommen werden und überall aus jeder Hand entstehen. Jeder kann...ktivität die geistige Fi...
...Was für Rick und Maria eine meditative Kunstform ist, bezeichnen vi...uationen beruhigen und...
...als „Tunnelblick", Yogalehrer als „heiligen Raum"; andere würden es...mplexen Inhalten aus...
...Konzentration" nennen. Mit Zentangle entstehen nicht nur schöne Ku...n – wie wenn man n...
...der Hektik des modernen Lebens etwas entgegenzusetzen. Studien be...m Schaffen von Mu...
...ktivität die geistige Fitness steigert, zu Kreativität anregt, die Stimm...vie die Augen-Har...

...er than on the farm, and that the money r...
...the city was deceptive. Some of these youn...
...satisfied to return to the farm after finding
...e no headway in the city.
...rmers' sons who have gone to the city have u...
...carry on a small business, perhaps with insuf...
...ad have failed, and some of these men hav...
...o agriculture.
...small regions it was discovered that the retu...
...included in its movement "retired" farmers...
...ed to the town with the expectation of spendin...
...of their days there, but had become homesi...
...town life to be short of expectations.
...often happened that men who have pass...
...ave not advanced in city occupations as...
...selves with small means and with t...
...becoming more and more unpromisin...
...tributed considerably to the mover...
...siderably in numbers, but not us...
...While most of them have been...
...d in the country in boyhood, oth...
...perience in agriculture or country...
...ruggle to establish themselves.

...OLONIES OF VARIOUS SOR...

...ural colonies, while not very nu...
...ness, the most successful one...
...established for the single purp...
...Italians have gone to Arkansas, f...
...ged in fruit culture and other lines...
...Poles have left Chicago to beco...
...so on with people of other nationa...
...owever, were an agricultural people in...
...in the cities of this country only tempo...
...t they might accumulate savings sufficie...
...themselves as farmers.
...ural colonies of another sort have been establi...
...ntained under the control of a competent ou...
...ent, as, for instance, the Jewish colonies in...
...New York, and New England, and the Salva...
...omes.

Yearbook of the Department of Agriculture.

Agricultural colonies of still another sort have been those
that were held together, sometimes poorly so, or briefly, by
some bond of social or religious or economic theory. New
colonies of this sort have been very few within the last
dozen years.

PREFERENCE FOR COUNTRY LIFE.

It has by no means been true that the movement from
city and town to the farm for permanent residence has in-
cluded ... or less failures in their
... their satisfaction,
... ncertainties of
... luded many
... mes men
... ve not
... they
... for
... ng-
... e,
... y
... n
... en
... an
... y so.
... before
... vertise-
... changing
... for truck
... oultry as an
... uring the summer
... an extensive business
...ll farms for the purpose
... g of boarders.
... farm to secure
... movement in

was higher than o...
wages in the city v...
have been satisfied
they made no head...
Other farmers' s...
taken to carry on ...
capital, and have ...
turned to agricult...
In some small re...
the farm included ...
had moved to the ...
remainder of their ...
had found town li...
It has often hap...
age and have not a...
found themselves ...
prospect becoming ...
have contributed ...
ture—considerably ...
formance. While ...
have lived in the ...
or no experience i...
a hard struggle to...

Agricultural co...
been noticeable. ...
that were establi...
living. Italians ...
have engaged in ...
colonies of Poles ...
Texas, and so on ...
people, however, ...
have lived in the ...
order that they ...
establish themsel...
Agricultural co...
and maintained ...
management, as, ...
Jersey, New Yor...
Army colonies.

Yearbook

...er than on the farm, and that the mon...
...the city was deceptive. Some of thes...
...n satisfied to return to the farm afte...
...le no headway in the city.
...farmers' sons who have gone to the c...
...carry on a small business, perhaps ...
...and have failed, and some of the...
...o agriculture.
...w small regions it was discovered...
...included in its movement "retir...
...ed to the town with the expectatio...
...of their days there, but had bee...
...f town life to be short of expecta...
...often happened that men who hav...
...have not advanced in city occupations...
...emselves with small means and with...
...becoming more and more unpromising...
...tributed considerably to the movement...
...siderably in numbers, but not usually...
...While most of them have been farmers...
...d in the country in boyhood, others have...

those was higher than o...
by wages in the city v...
ew have been satisfied
st they made no head...
Other farmers' s...
taken to carry on ...
capital, and have ...
turned to agricult...
In some small re...
the farm included ...
had moved to the ...
remainder of their ...
had found town li...
It has often hap...
en age and have not a...
not found themselves ...
t they prospect becoming ...
ence for have contributed ...
en a long- ture—considerabl...
a farm home, formance. While

publicação pode usar

rminada por sua estrutura gera

sangradas de cima a bai

exemplo, muitas vezes são divididas em

ens bem grandes sangradas de cima a bai

r exemplo, muitas vezes são divi

guras de coluna diferen

rtes: uma série de seções fixas que aparec

uma cobrindo larguras de coluna diferen

rtes: uma série de seções fixas qu

, para criar uma quebra l

sma ordem em todas as edições, acompanh

caladas por texto, para criar uma quebra l

sma ordem em todas as edições, a

guinte pode inverter es

r uma sequência de matérias que mudam

spaço; a seção seguinte pode inverter es

r uma sequência de matérias que

strutura de linhas e cria

da edição. Em cada tipo de publicação, há

a, enfatizando a estrutura de linhas e cria

da edição. Em cada tipo de public

âmicos de imagens e dos

a chance de que essas seções predetermin

os arranjos panorâmicos de imagens e dos

a chance de que essas seções pred

nham. A primeira aborda

am diferentes, uma vez que apresentam

os que as acompanham. A primeira aborda

am diferentes, uma vez que apre

qualidade veloz, de ediç

nteúdos diferentes. Dentro de cada seção,

tural gera uma qualidade veloz, de ediç

nteúdos diferentes. Dentro de cad

ia das páginas duplas,

signer também deve estabelecer uma vari

da, para a cadência das páginas duplas,

signer também deve estabelecer

roduz uma sensação ma

ual para que o leitor, embora reconheç

uanto a segunda produz uma sensação ma

ual para que o leitor, embora rec

agens suspensas por un

rutura consistente, não fique entediado.

prolongada. Imagens suspensas por un

rutura consistente, não fique en

na ao topo de uma pági

os esquemas de cores gerais de diversas s

horizontal próxima ao topo de uma págin

os esquemas de cores gerais de d

raste com outra página

modificando a linguagem visual das ima

la criarão um contraste com outra página

modificando a linguagem visual

ndem de uma guia horiz

tipografia de uma página dupla para ou

ual as imagens pendem de uma guia horiz

tipografia de uma página dupla

as imagens são sangrad

ou criando uma progressão de valor ou

s baixa ou à qual as imagens são sangrada

ou criando uma progressão de v

essas estratégias estrut

complexidade, do claro para o escuro ou

os os lados. O uso dessas estratégias estrutu

complexidade, do claro para o e

refletir alguma sensação

simples para o complicado, é uma estrat

ser arbitrário ou refletir alguma sensação

simples para o complicado, é um

ores gerais de diversas s

alternativa que afeta principalmente o c

os esquemas de cores gerais de diversas s

alternativa que afeta principalm

nguagem visual das ima

Essa abordagem à cadência é bem menos

modificando a linguagem visual das ima

Essa abordagem à cadência é ber

a página dupla para ou

neutra em seus resultados e afeta muito

tipografia de uma página dupla para

progressão de valor ou

mais as mensagens transmitidas por seç

ou criando uma prog

o claro para o escuro o

ou páginas duplas individuais, assim co

complexidad

mplicado, é uma estrat

jornada emocional que o leitor experim

impl

feta principalmente o c

nplo, uma seção de publicação pode usar

a cadência é bem meno

gens bem grandes sangradas de cim

esultados e afeta muito

uma cobrindo larguras de col

ns transmitidas por seç

rcaladas por texto, para cria

s individuais, assim co

spaço; a seção seguinte

al que o leitor experim

ca, enfatizando a est

unicação; seu objetivo é

os arranjos pano

u mesmo páginas dupla

os que as acom

por meio da articulação

utural gera

id de formas perceptivel

da, para

o modo, usando um gri

uanto a

o ou página dupla, para

a e pr

articular. A variação est

ho

o ritmo, dentro do qual

la

de escala e de posição, r

e permanece o mesmo

ko de uma publicação

estrutura geral. As

s vezes são dividida

seções fixas que a

das as edições, aco

le matérias que r

a tipo de publica

ssas seções pred

na vez que apre

s. Dentro de cad

ve estabelecer u

ECONOMIC INDEPENDENCE.

The motives that have actuated this movement from city and town to the farm for permanent residence have been very numerous. Many of these have already incidentally been mentioned. Perhaps as prevalent a motive as any has been the belief that an economic independence of the family can be maintained by poultry raising or, at any rate, largely supplemented. It was easy to demonstrate this with pencil and paper before establishing or acquiring a "poultry farm," as the advertisements called it. In the more promising plans for changing from city to farm life, provision has been made for truck crops, berries, and perhaps small fruits, with poultry as an adjunct.

The keeping of boarders from the city during the summer and early autumn has become such an extensive business that city families have acquired small farms for the purpose of combining agriculture with the keeping of boarders. Other families have been forced to the farm to secure better health, and still others have joined the movement in...

PREFERENCE FOR COUNTRY LIFE.

It has by no means been true that the movement from ... in its movement "retired" farmers and town to the farm for permanent residence has included only those men who were more or less failures in their days there, but had become homesick, men who have not thriven to their satisfaction, and men who have desired to escape the uncertainties of ... and men who have passed ... employment for wages. This migration has included many advanced in city occupations as they ... of means and agricultural intelligence, sometimes men with small means and with their accumulated a competence. These men have not been forced out to the farm by economic pressure, but they have followed lines of economic pleasure and preference for ... in numbers, but not usually so ... life, and with some of them there has been a long-... most of them have been farmers ... realization of a dream of happy life in a farm home ... country in boyhood, others have had often with surroundings of a beautiful nature. ... agriculture or country life, and have ...

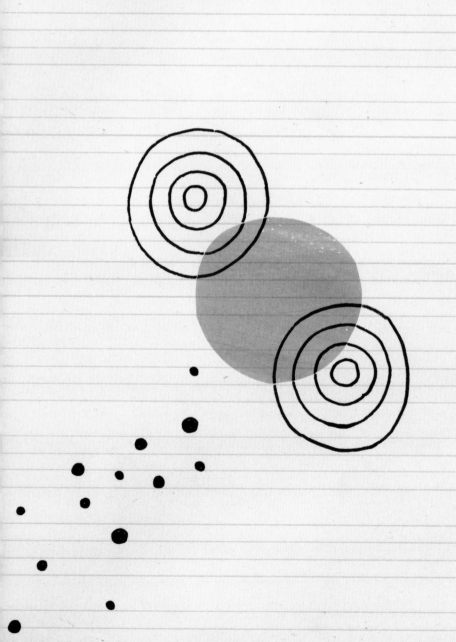

ave bee... ...oned.
...ose of getti... the belief tha...
...for instance, ...be maintained ...
...lines of agricul... It was easy to de...
...o become farme... establishing or ac...
nationalities. ...ments called it. ...
people in Europe ...from city to farm
...y only temporari... crops, berries, and
...avings sufficien... adjunct.

The keeping of ...
...e been establi... and early autu...
...petent ou... that city famil...
...pies in ...of combini...
...ly. Other...

...ltiplient à une vitesse fo...

objectifs en tête : favoriser l'ins...

...ultes et enfants à valoriser le poten...

...eut. À vous la liberté de créer! Ces proj...

...ction, le sans-faute absolu. Au contraire : il...

...ique, mais de vous inspirer de ces idées pour...

de papier, de boîtes et de livres. pas les instruct...

...cutiez ces projets avec vos enfants ou que vous s...

...ésitez pas à suivre votre instinct pour les couleurs,...

Ne considérez pas les instructions données ici comm...

créatives. En résumé, j'espère que ce livre vous donn...

d'entrer dans l'imaginaire de votre enfant à travers l'a...

Que vous exécutiez ces projets avec vos enfants ou c...

cadeaux, n'hésitez pas à suivre votre instinct pour les...

matériaux. Ne considérez pas les instructions donnée...

...e d'aller bien loin pour dénicher le matériel dont vous...

...e trouve dans la boîte aux lettres, les tiroirs du bureau...

peille à papier. Les possibilités de recyclage et de réc...

...e déclinent à l'infini, même avec des choses aussi b...

...nés, des boîtes à chaussures ou des chutes de pap...

...la main à la pâte, les idées se multiplient à une vit...

...et ouvrage avec trois objectifs en tête : favoris...

...encourager adultes et enfants à valoriser le...

...nne ne veut. À vous la liberté de créer! Ce...

...rfection, le sans-faute absolu. Au contra...

...e, mais de vous inspirer de ces idée...

de boîtes et de livres. déclinen...

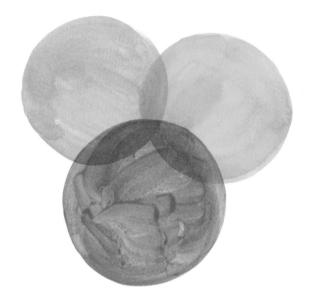

Quarto is the authority on a wide range of topics.

Quarto educates, entertains and enriches the lives of
our readers—enthusiasts and lovers of hands-on living.

www.QuartoKnows.com

First published in the United States of America in 2016 by
Quarry Books, an imprint of
Quarto Publishing Group USA Inc.
100 Cummings Center
Suite 406-L
Beverly, Massachusetts 01915-6101
Telephone: (978) 282-9590
Fax: (978) 283-2742
QuartoKnows.com
Visit our blogs at QuartoKnows.com

10 9 8 7 6 5 4 3 2 1

ISBN: 978-1-63159-137-2
eISBN: 978-1-63159-201-0

Library of Congress Cataloging-in-Publication Data available.

Design: Megan Jones Design
Cover Image: Sarah Walsh
Interior art: Sarah Walsh; pages 7, 9, 11, Quarry staff

Printed in China

About the Author

Sarah Walsh is a Kansas City-based artist and illustrator. She's the author/illustrator of the
first book in this series: *100 Things to Draw with a Triangle*, and three Just Add Color titles
for Rockport Publishers: *Circus*, *Carnival*, and *Day of the Dead*. Sarah is inspired by animals,
magical creatures, coffee, music, a good story, her friends and family, bravery, vintage
children's books, folk art, and mid-century anything.